To _____

From_____

Inspirations

The Miracle of Baby Animals in Pictures and Scripture

PHOTOGRAPHY BY **Lisa and Mike Husar**

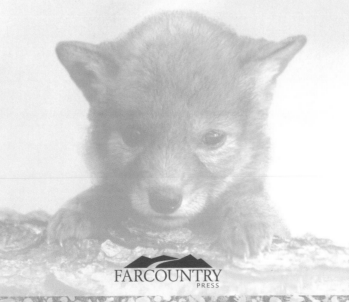

FARCOUNTRY
PRESS

ISBN 10: 1-56037-408-X
ISBN 13: 978-1-56037-408-4
Photography © 2006 by Lisa & Mike Husar/TeamHusar.com
Photos, pages 5 & 60 (dandelion), 23 (flower), 27 (lily), 54 (Indian paintbrush),
62 (aspen leaves) © 2006 JupiterImages Corporation
© 2006 by Farcountry Press

All scripture is from the New International Version of the Bible.

For more information about our books, write Farcountry Press, P.O. Box 5630, Helena, MT 59604;
call (800) 821-3874; or visit www.farcountrypress.com.

Created, produced, and designed in the United States. Printed in China.

10 09 08 07 06 1 2 3 4 5

COYOTE PUP

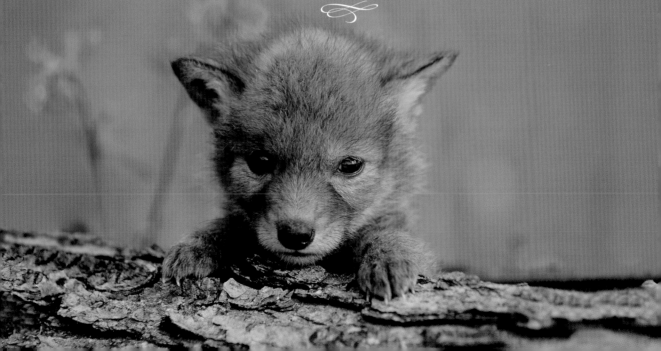

ut ask the animals, and they will teach you,

or the birds of the air, and they will tell you;

or speak to the earth, and it will teach you,

or let the fish of the sea inform you.

Which of all these does not know that

the hand of the Lord has done this?

In his hand is the life of every creature

and the breath of all mankind.

JOB 12:7-10

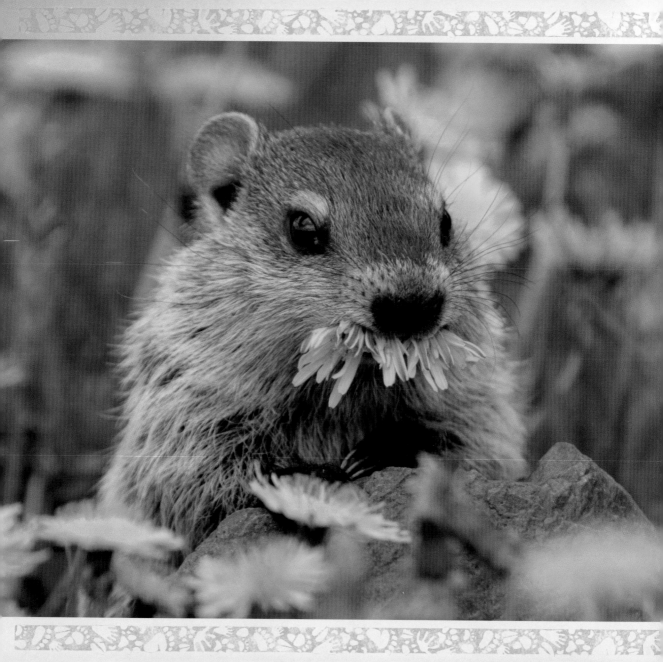

The eyes of all look to you,

and you give them their

food at the proper time.

You open your hand and satisfy

the desires of every living thing.

PSALM 145:15-16

YOUNG WOODCHUCK

Come, let us sing for joy to the Lord;

let us shout aloud to the Rock of our salvation.

Let us come before him with thanksgiving

and extol him with music and song.

For the Lord is the great God,

the great King above all gods.

In his hand are the depths of the earth,

and the mountain peaks belong to him.

The sea is his, for he made it,

and his hands formed the dry land.

PSALM 95:1-5

GRAY WOLF PUP

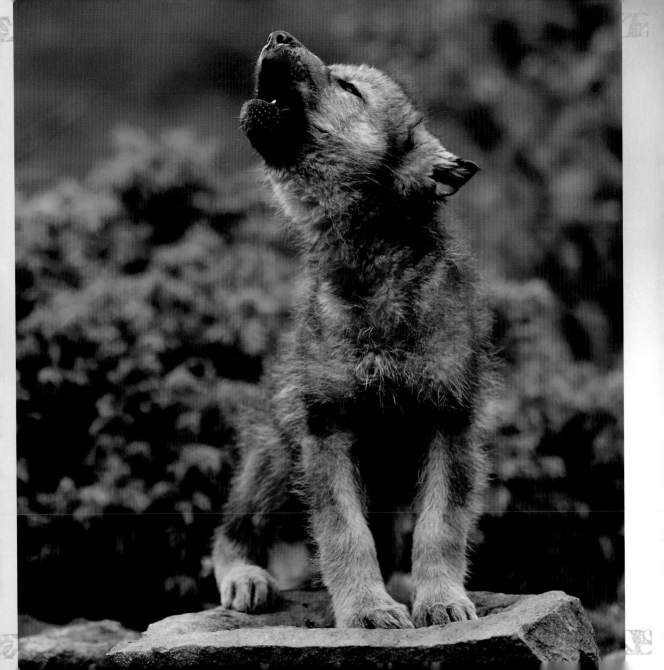

Can a mother forget the baby at her breast and

have no compassion on the child she has borne?

Though she may forget, I will not forget you!

See, I have engraved you on the palms of my hands;

your walls are ever before me.

ISAIAH 49:15-16

ELEPHANT CALF

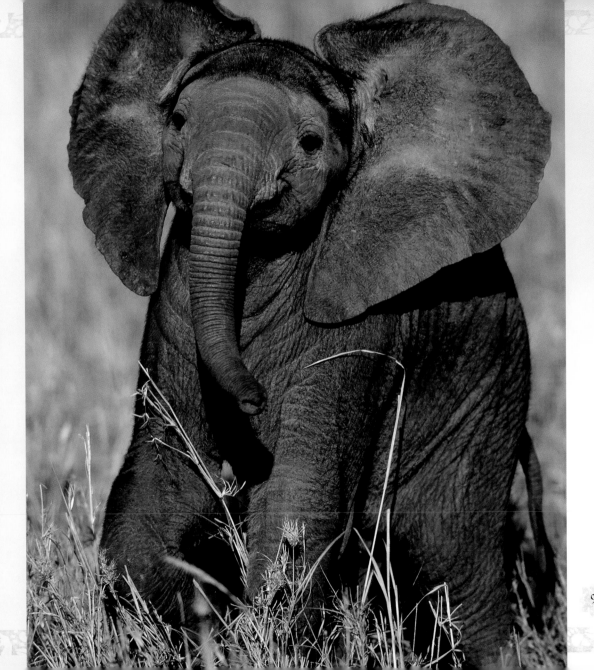

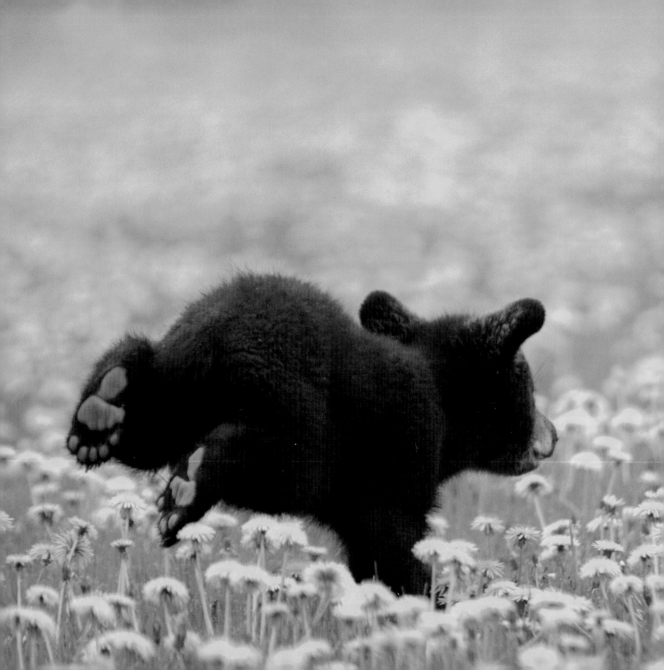

Do you not know that in

a race all the runners run,

but only one gets the prize?

Run in such a way as to

get the prize.

1 CORINTHIANS 9:24

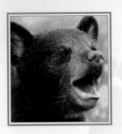

BLACK BEAR CUB

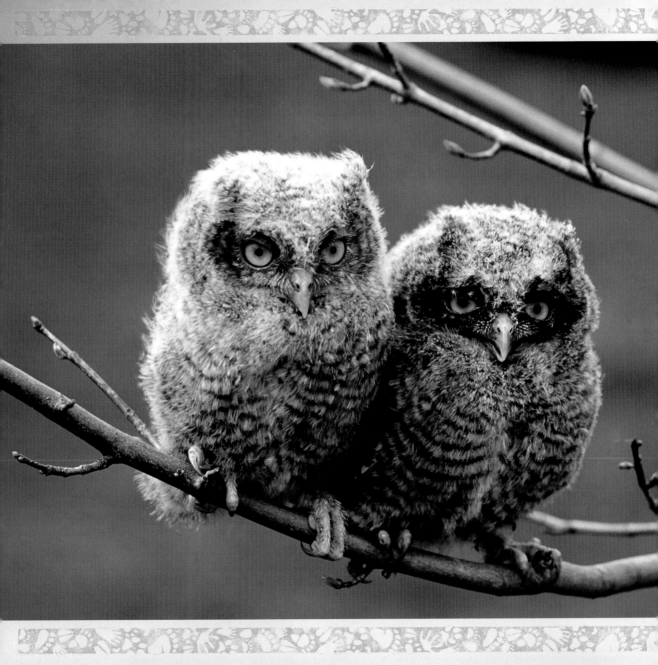

A father to the fatherless,

a defender of widows,

is God in his holy dwelling.

God sets the lonely in families.

PSALM 68:5-6

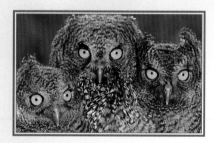

SCREECH OWLETS

For I know the plans I have for you,

declares the Lord, plans to prosper

you and not to harm you, plans

to give you hope and a future.

Then you will call upon me and

come and pray to me, and I will

listen to you. You will seek me

and find me when you seek me

with all your heart.

JEREMIAH 29:11-13

RED FOX KIT

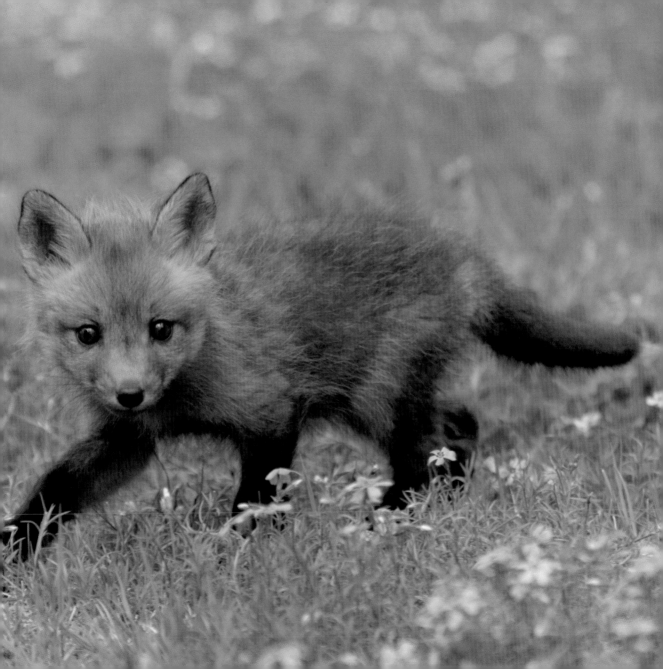

\mathcal{B}y faith we understand that the universe

was formed at God's command,

so that what is seen was not made

out of what was visible.

HEBREWS 11:3

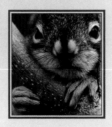

JUVENILE RED SQUIRREL

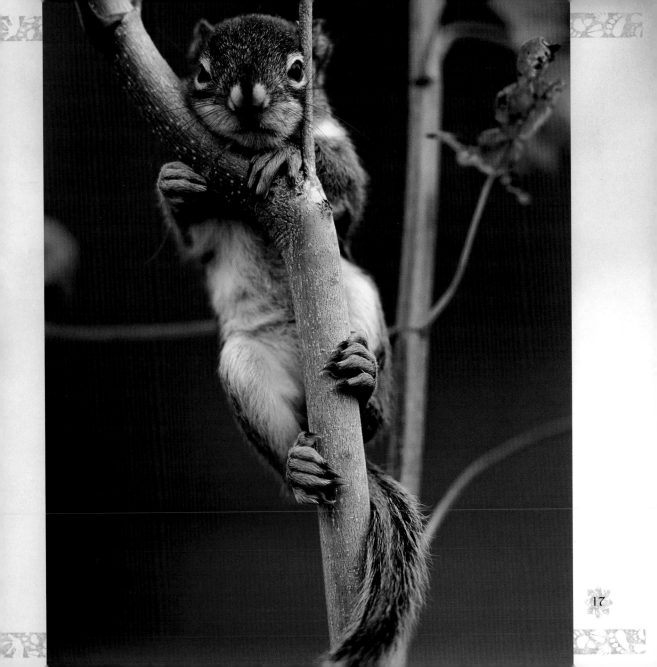

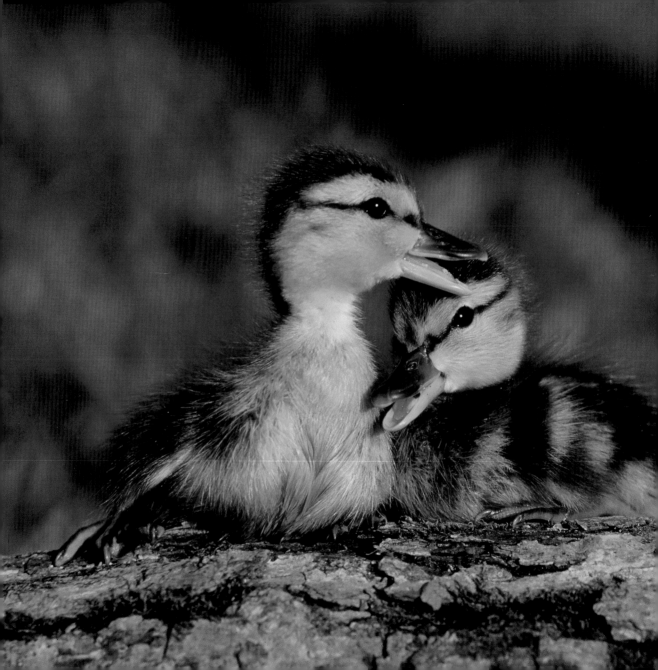

\mathcal{B}e strong and courageous.

Do not be terrified;

do not be discouraged,

for the Lord your God will

be with you wherever you go.

JOSHUA 1:9

MALLARD DUCKLINGS

The Lord is my rock,

my fortress and my deliverer;

my God is my rock,

in whom I take refuge.

He is my shield and the horn of my salvation,

my stronghold.

PSALM 18:2

YOUNG PORCUPINE

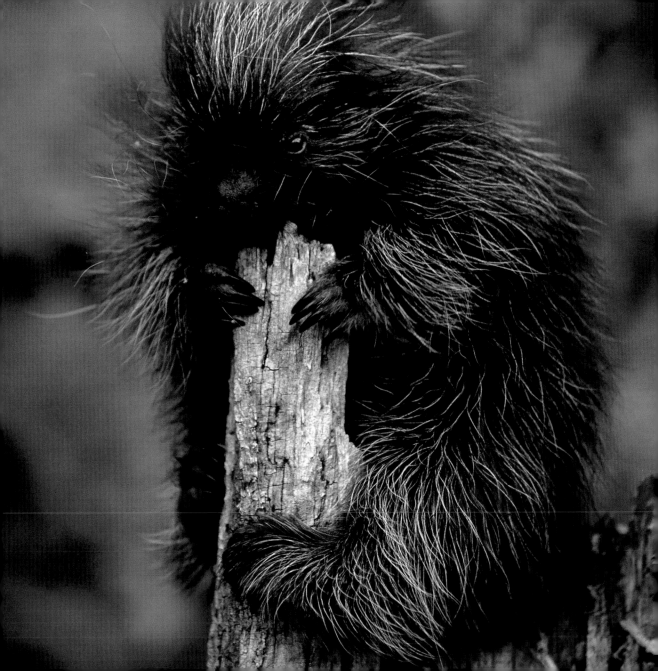

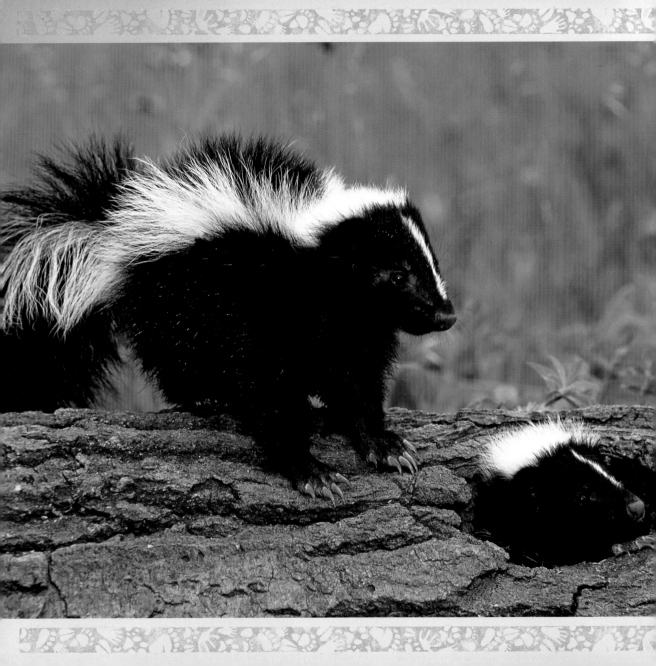

*T*wo are better than one,

because they have a good

return for their work:

If one falls down,

his friend can help him up.

But pity the man who falls

and has no one to help him up!

ECCLESIASTES 4:9-10

SKUNK KITS

*I*t is God who arms me with strength

and keeps my way perfect.

He makes my feet like the feet of a deer;

he enables me to stand on the heights.

PSALM 18:32-33

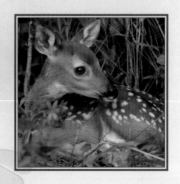

WHITE-TAILED DEER FAWNS

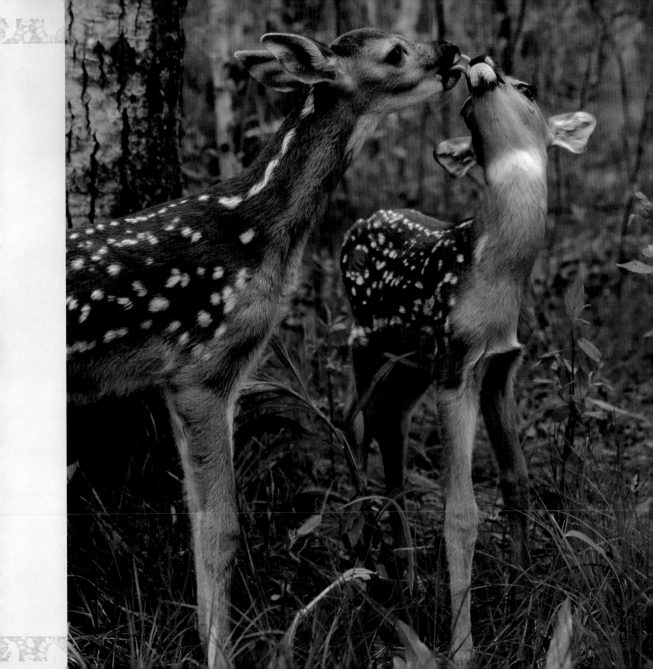

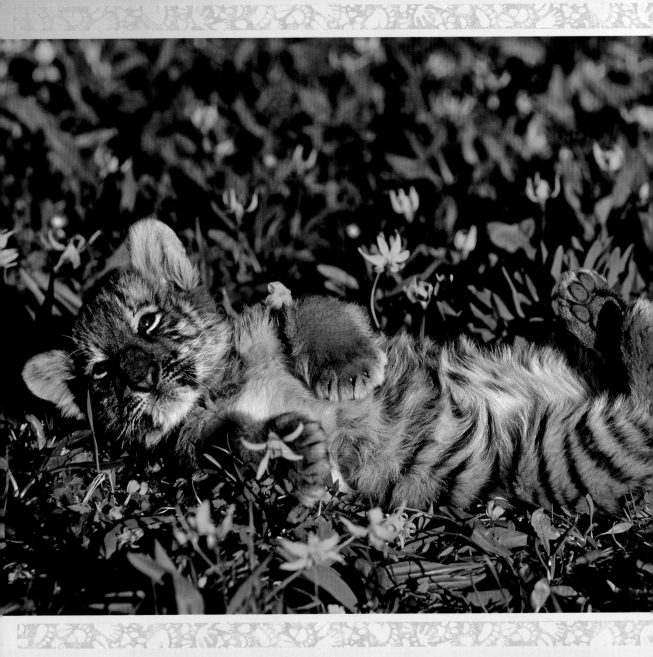

*I*n that day I will make a covenant

for them with the beasts of

the field and the birds of the

air and the creatures that move

along the ground.

Bow and sword and battle

I will abolish from the land,

so that all may lie down in safety.

HOSEA 2:18

SIBERIAN TIGER CUB

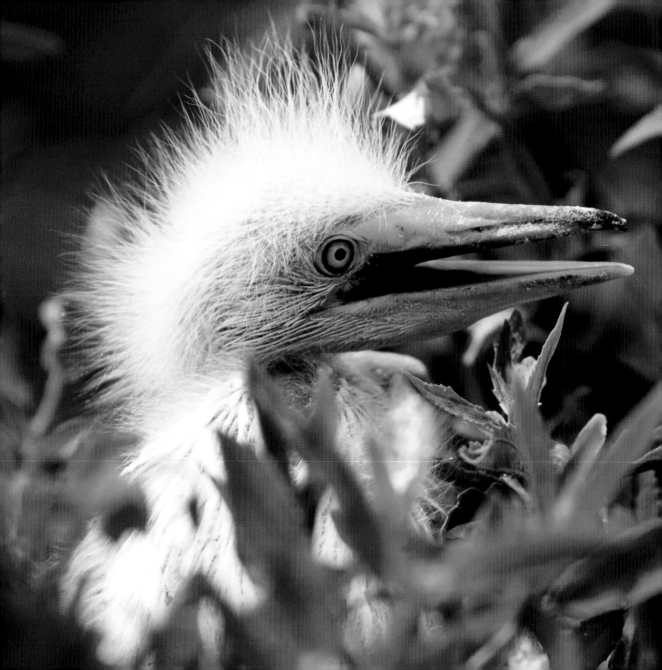

*D*o not consider his appearance

or his height,

for I have rejected him.

The Lord does not look

at the things man looks at.

Man looks at the outward appearance,

but the Lord looks at the heart.

1 SAMUEL 16:7

GREAT EGRET CHICK

\mathcal{H}ow many are your works, O Lord!

In wisdom you made them all;

the earth is full of your creatures.

There is the sea, vast and spacious,

teeming with creatures beyond number—

living things both large and small.

PSALM 104:24-25

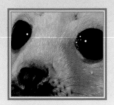

HARP SEAL PUP

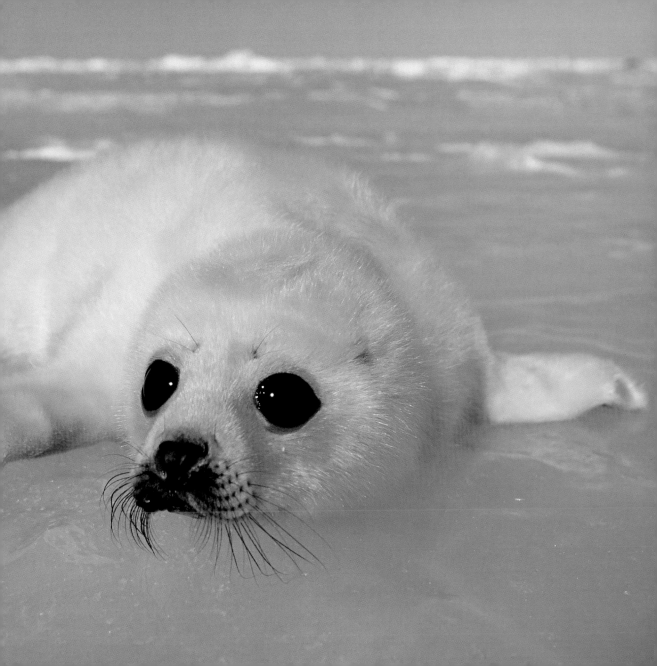

\mathcal{A} friend loves at all times,

and a brother is born for adversity.

PROVERBS 17:17

BOBCAT KITTENS

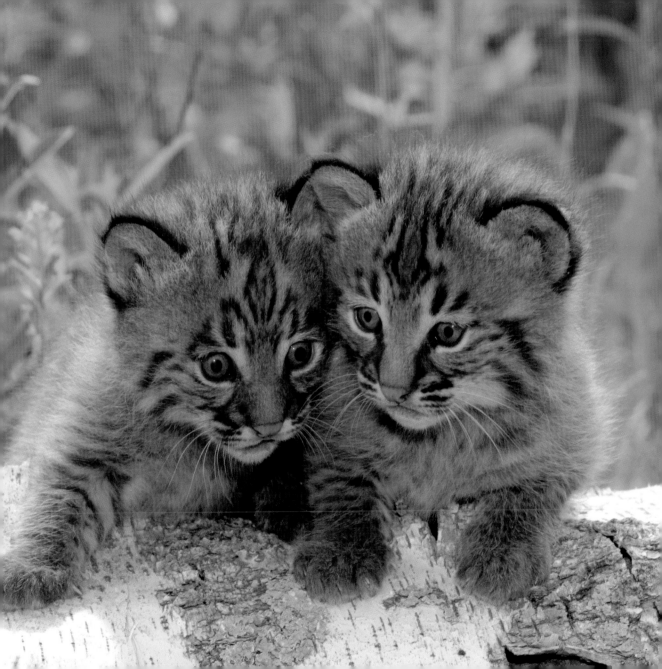

Let us then approach the throne

of grace with confidence,

so that we may receive mercy

and find grace to help us in

our time of need.

HEBREWS 4:16

GIRAFFE CALF

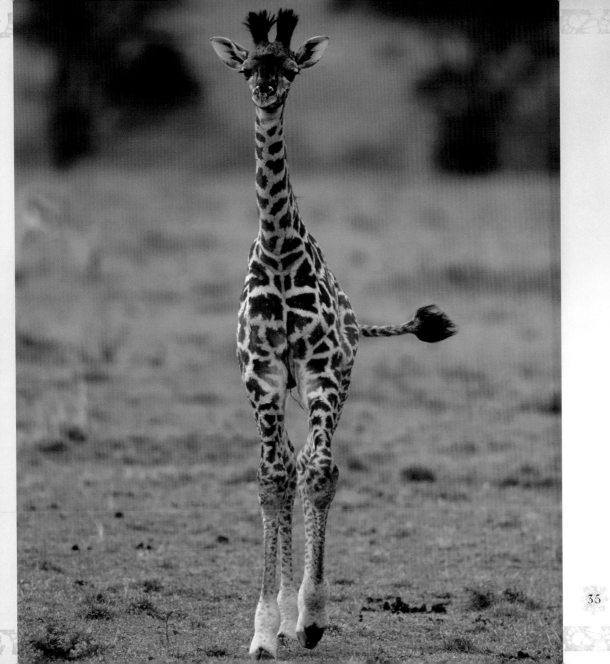

*W*ith my great power and outstretched

arm I made the earth and its people

and the animals that are on it,

and I give it to anyone I please.

JEREMIAH 27:5

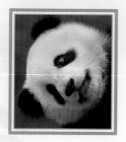

GIANT PANDA BEAR CUB

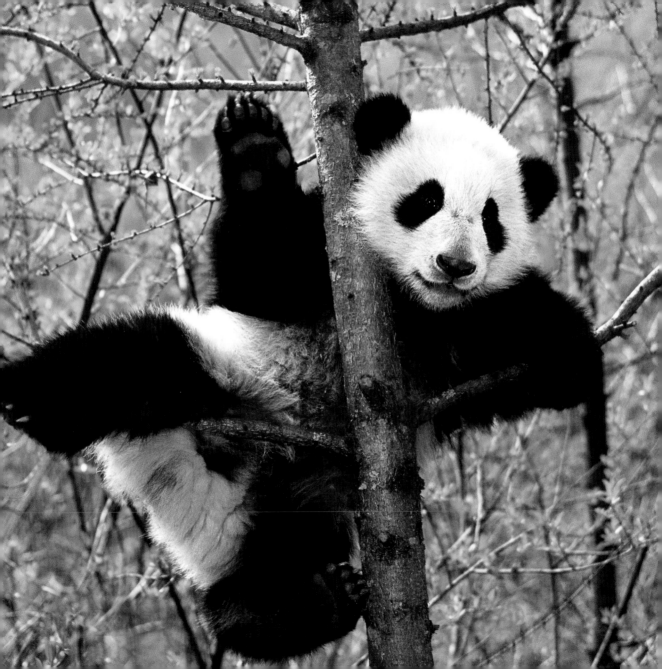

*B*e completely humble and gentle;

be patient, bearing with one another in love.

EPHESIANS 4:2

ARCTIC FOX KIT

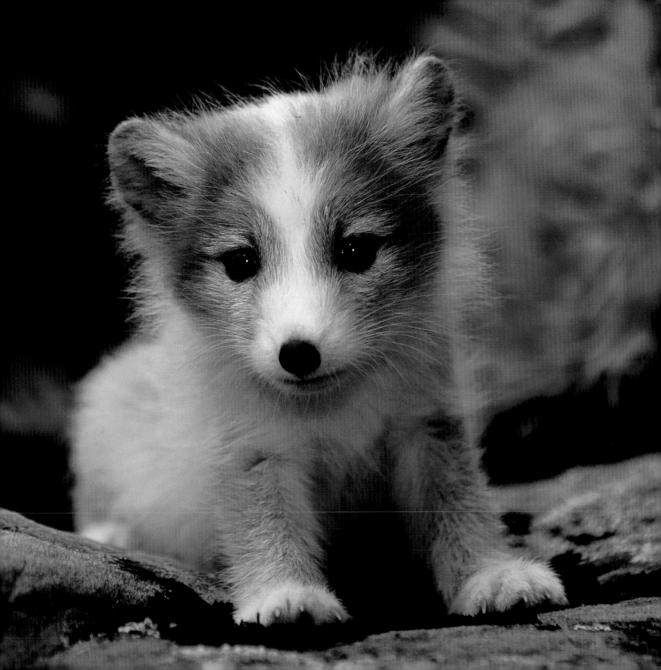

*S*ay to God, "How awesome
are your deeds!

So great is your power that

your enemies cringe before you.

All the earth bows down to you;

they sing praise to you,

they sing praise to your name."

PSALM 66:3-4

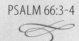

LION CUBS

Humble yourselves, therefore,

under God's mighty hand,

that he may lift you up in due time.

Cast all your anxiety on him

because he cares for you.

1 PETER 5:6-7

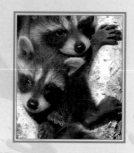

RACCOON KITS

ook at the birds of the air;

they do not sow or reap

or store away in barns,

and yet your heavenly

Father feeds them.

Are you not much more

valuable than they?

MATTHEW 6:26

ROBIN CHICKS

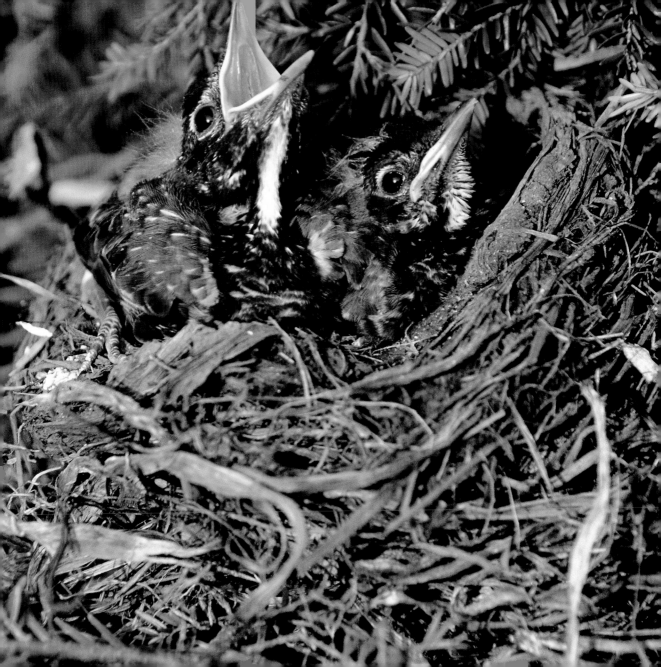

*A*nswer me, O Lord,

out of the goodness of your love;

in your great mercy turn to me.

Do not hide your face from your servant;

answer me quickly, for I am in trouble.

Come near and rescue me;

redeem me because of my foes.

PSALM 69:16-18

POLAR BEAR CUBS

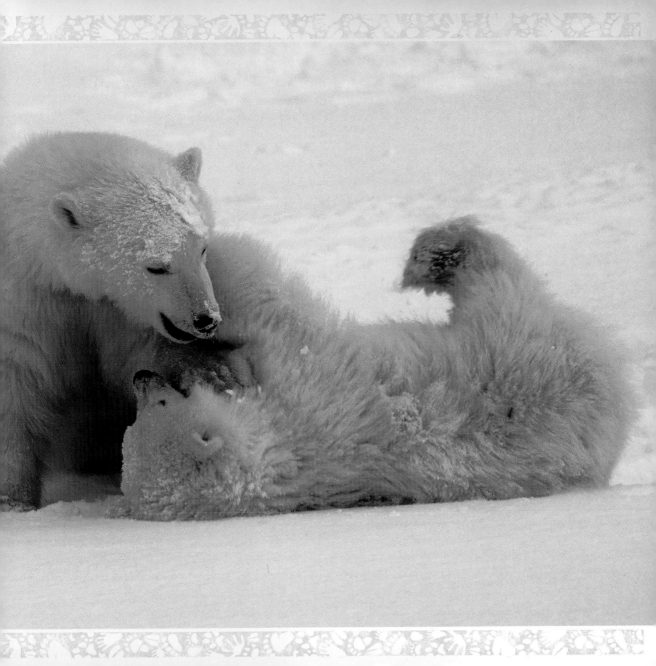

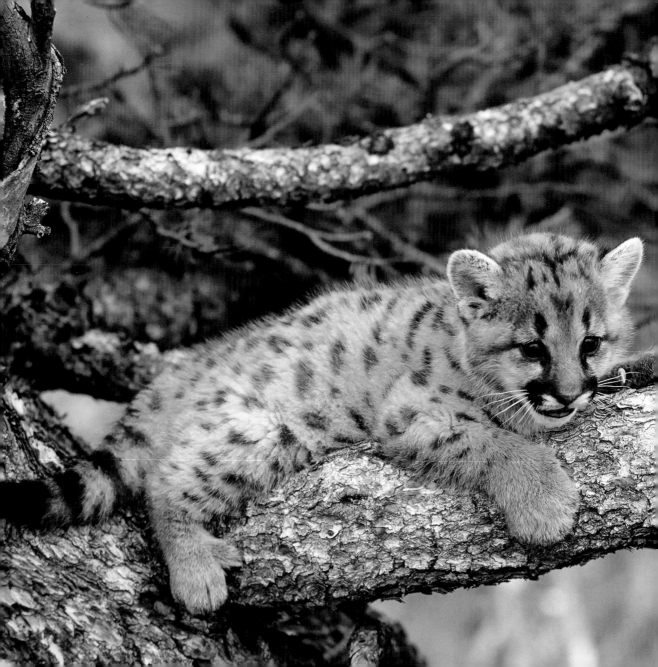

God made the wild animals
according to their kinds,
the livestock according
to their kinds,
and all the creatures that
move along the ground
according to their kinds.
And God saw that it was good.

GENESIS 1:25

MOUNTAIN LION CUB

49

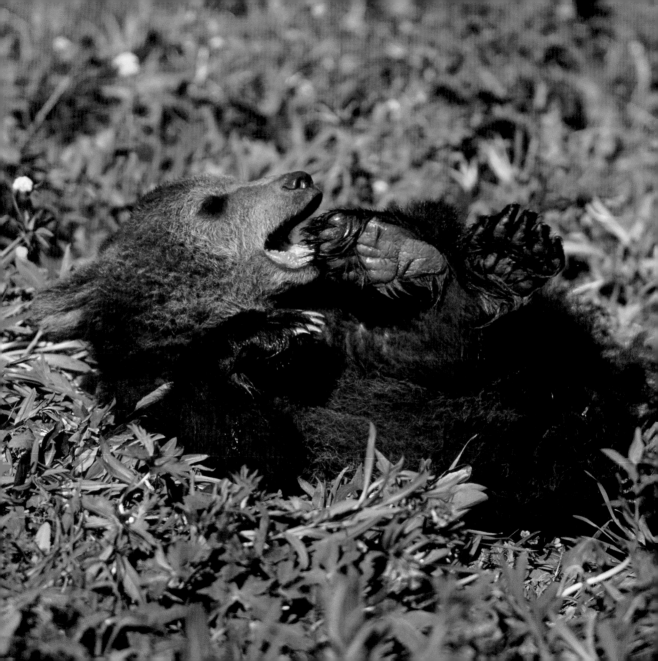

For nothing is impossible with God.

GRIZZLY BEAR CUB

Turn your ear to me,

come quickly to my rescue;

be my rock of refuge,

a strong fortress to save me.

PSALM 31:2

PINE MARTEN KIT

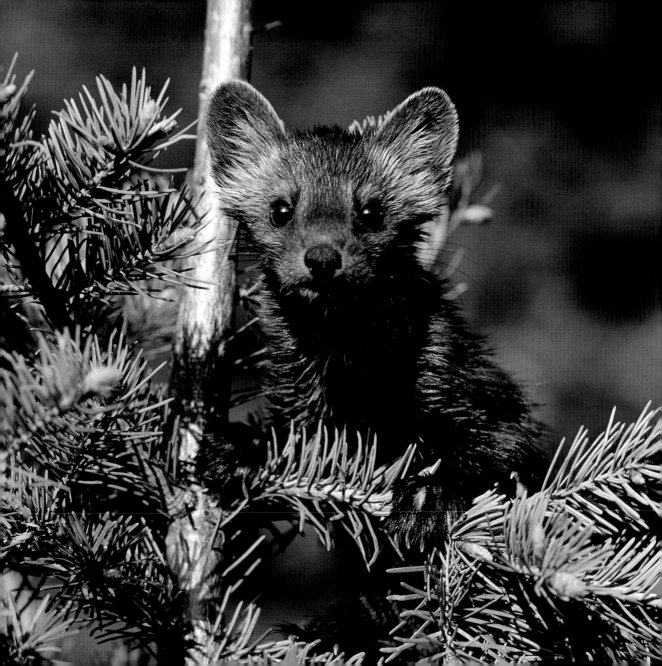

He who forms the mountains,

creates the wind,

and reveals his thoughts to man,

he who turns dawn to darkness,

and treads the high places of the earth—

the Lord God Almighty is his name.

AMOS 4:13

LYNX KITTENS

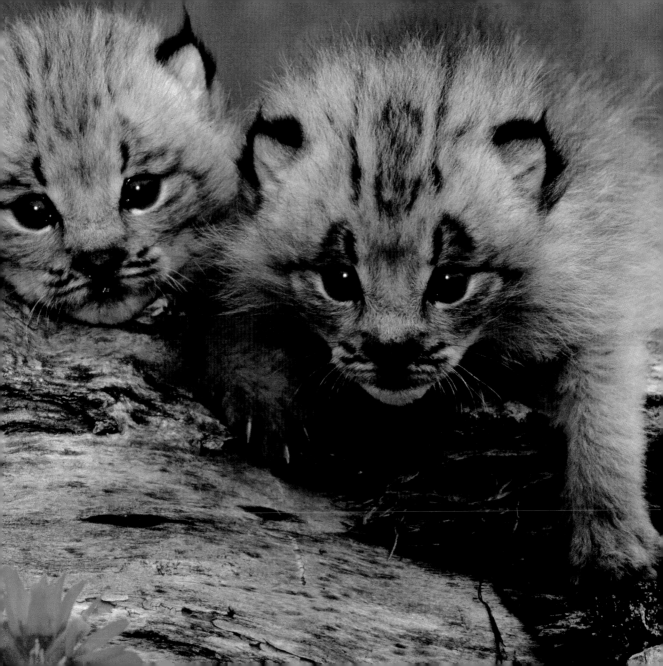

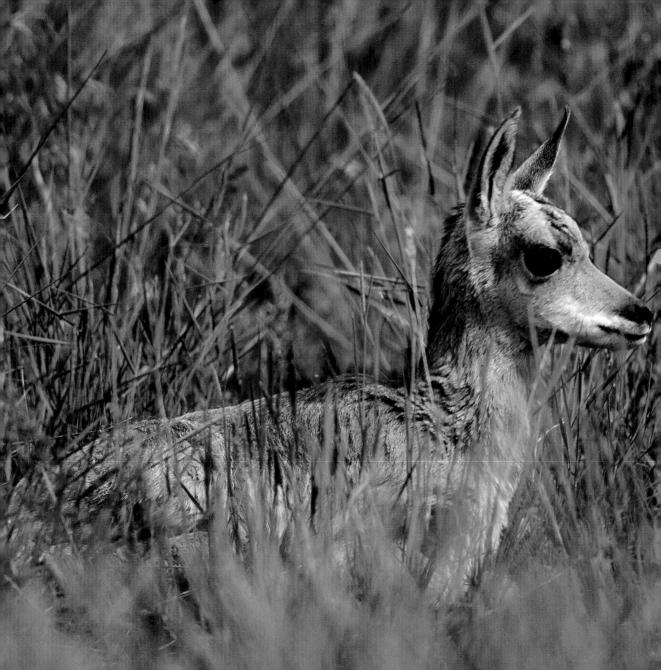

\mathcal{N}ow the Lord God had formed out of
the ground all the beasts of the field
and all the birds of the air.
He brought them to the man to see
what he would name them;
and whatever the man called each
living creature, that was its name.
So the man gave names to all the
livestock, the birds of the air and
all the beasts of the field.

GENESIS 2:19-20

PRONGHORN FAWN

For hardship does not spring from the soil,

nor does trouble sprout from the ground.

Yet man is born to trouble

as surely as sparks fly upward.

But if it were I, I would appeal to God;

I would lay my cause before him.

He performs wonders that cannot be fathomed,

miracles that cannot be counted.

He bestows rain on the earth;

he sends water upon the countryside.

The lowly he sets on high,

and those who mourn are lifted to safety.

JOB 5:6-11

OPOSSUM PUP

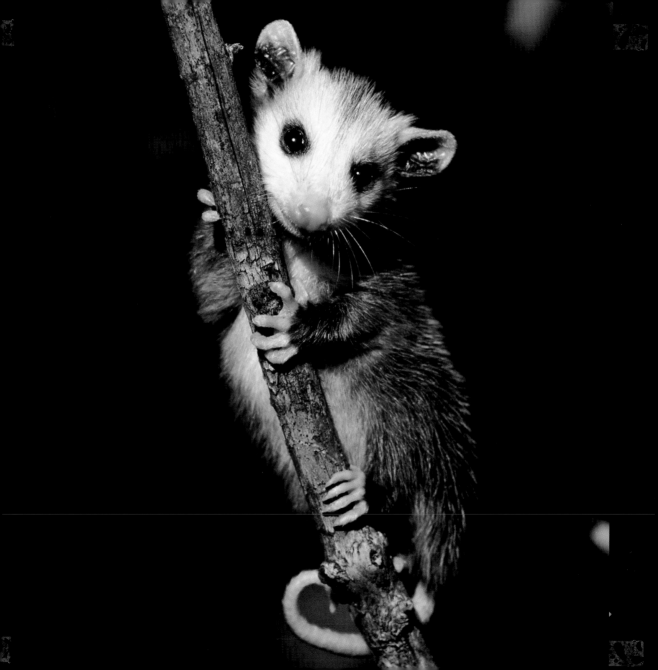

Then he said to them,
"Whoever welcomes this little
child in my name welcomes me;
and whoever welcomes me
welcomes the one who sent me.
For he who is least among you all—
he is the greatest."

LUKE 9:48

GRAY FOX KIT

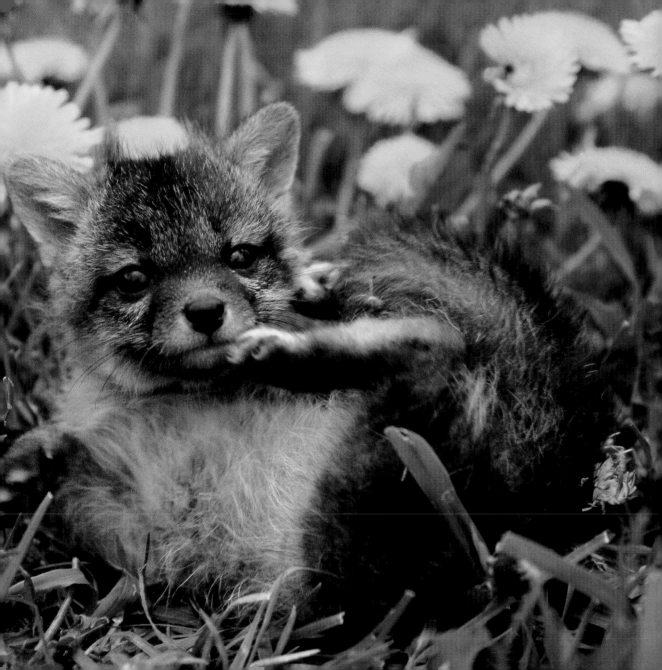

I will bow down toward your holy temple and will praise your name for your love and your faithfulness, for you have exalted above all things your name and your word. When I called, you answered me; you made me bold and stouthearted.

PSALM 138:2-3

BLACK BEAR CUB

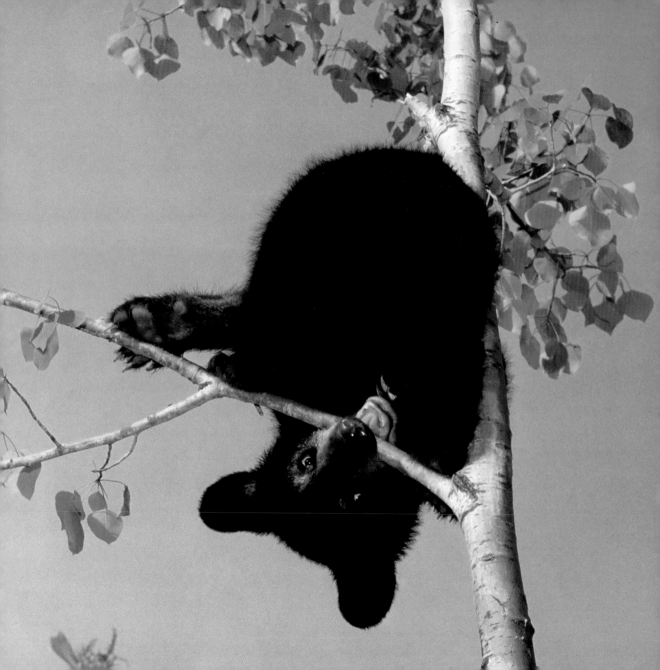

*L*isa and Mike Husar have been captivating animal lovers with their images since 1993, when they founded Team Husar Wildlife Photography. Passionate about wildlife conservation, the husband and wife team seek to use their images to spread the message about preserving the Earth's wild creatures. Lisa and Mike live in West Bend, Wisconsin, with their own "wild" animals: Bear, a golden retriever, and Teko, a small parrot. To see more of their work, visit www.teamhusar.com.